Date Due

BLY Ja 9 6		
FEB 10 1995		
MAR – 7 1996		
DEC 01 '98		

MUSKOKA

SOUVENIR

MUSKOKA

SOUVENIR

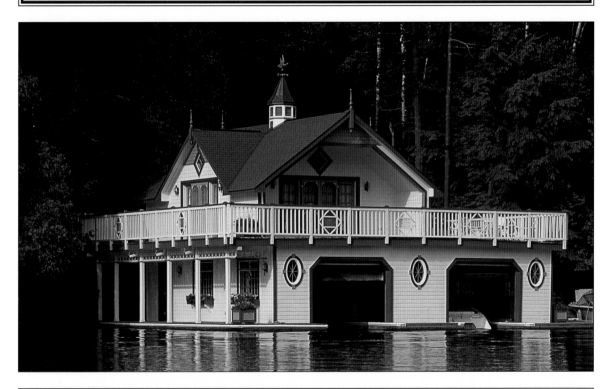

Photography by John de Visser • Text by Judy Ross

Stoddart

A BOSTON MILLS PRESS BOOK

Canadian Cataloguing in Publication Data

De Visser, John, 1930–
 Muskoka souvenir

ISBN 1-55046-125-7

1. Muskoka (Ont.) – Pictorial works. 2. Muskoka
(Ont.) – History. I. Ross, Judy, 1942–
II. Title

FC3095.M88D48 1995 971.3'1604'0222
F1059.M9D48 1995 C95-930790-7

First published in 1995 by
Stoddart Publishing Co. Limited
34 Lesmill Road
Toronto, Ontario
M3B 2T6
(416) 445-3333

A BOSTON MILLS PRESS BOOK
132 Main Street
Erin, Ontario
N0B 1T0

Design by Gillian Stead
Printed in Canada

OVERLEAF: Fanciful boathouse architecture

The publisher gratefully acknowledges the support of the Canada Council,
Ministry of Culture, Tourism and Recreation, Ontario Arts Council and
Ontario Publishing Centre in the development of writing and publishing in Canada.

Stoddart books are available for bulk purchase for sales promotions, premiums, fundraising, and seminars.
For details contact:
Special Sales Department, Stoddart Publishing Co. Limited, 34 Lesmill Road, Toronto, Ontario M3B 2T6
Tel. 1-416-445-3333 Fax 1-416-445-5967

CONTENTS

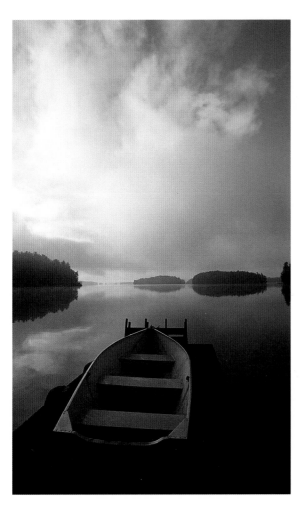

Still and silent Lake Muskoka

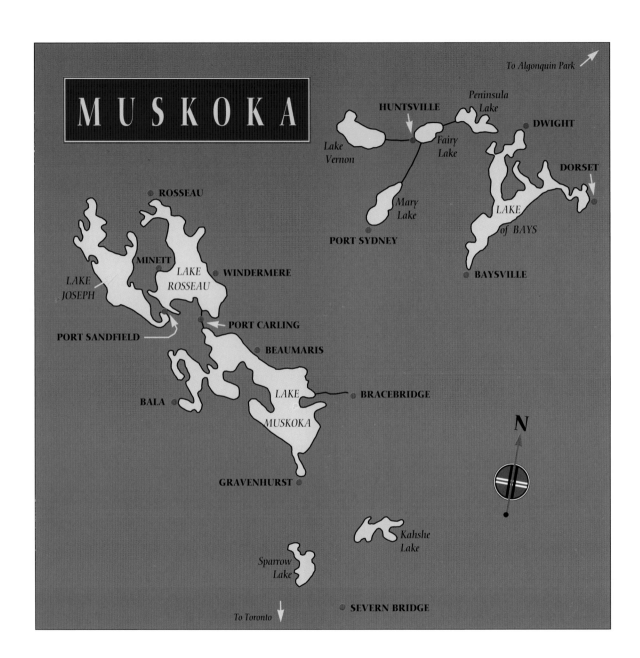

MUSKOKA

To Algonquin Park

HUNTSVILLE

Peninsula Lake

DWIGHT

Lake Vernon

Fairy Lake

DORSET

Mary Lake

LAKE of BAYS

ROSSEAU

PORT SYDNEY

BAYSVILLE

MINETT

LAKE ROSSEAU

WINDERMERE

LAKE JOSEPH

PORT CARLING

PORT SANDFIELD

BEAUMARIS

BALA

LAKE MUSKOKA

BRACEBRIDGE

N

GRAVENHURST

Kahshe Lake

Sparrow Lake

To Toronto

SEVERN BRIDGE

INTRODUCTION

My first look at Muskoka was at age ten, when I was taken to my aunt's cottage, a tiny cabin on a tiny island. After a long, hot drive from Toronto, much of it spent battling in the back seat of the car with my two younger sisters, we arrived at the mainland dock, and I still remember that first breath of fresh, pine-scented air. Once on the island, we immediately stripped off our city clothes, slipped into our bathing suits, and jumped off the front rock into the cool, silky water of Lake Muskoka. "Now you will always want to be here," my aunt said knowingly.

I have been in Muskoka every summer since. It's a resort district of immense beauty, admired by those who visit and cherished by those lucky enough to lay claim to a chunk of it. With its sparkling lakes and dense woodlands, its lakefront hotels and appealing towns, Muskoka is the most popular tourist destination in all of Ontario. The deep blue lakes (1,600 of them) are the area's major attraction, but its most compelling feature is its vast outcrops of rock. This is Canadian Shield country, and jagged slabs of pink granite jut from the thin soil all across the otherwise rolling landscape.

The district encompasses 1,473 square miles (3,815 km^2), extending from the shores of Georgian Bay in the west to Algonquin Park in the east; north past the town of Huntsville and south to the Trent–Severn inland waterway. The most famous of Muskoka's many lakes are the big three – Muskoka,

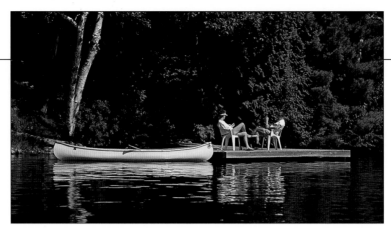

Lazy day at Lake of Bays

Rosseau and Joseph. Together they form 90 square miles (236 km²) of shore-line, much of it studded with handsome wooden cottages and unique boathouses.

Steamboat passengers first visited these lakes back in the 1800s. Some were settlers coming to farm the land; others were tourists visiting the newly built hotels. Today, steamboat travel has all but disappeared. Of a once large fleet, only the RMS *Segwun*, the oldest operating coal-fired steamship in Canada, remains. But seeing Muskoka from the water is still the preferred vantage point – if possible from aboard the *Segwun* herself.

On these pages you'll view this glorious lakeland through the eyes of master photographer John de Visser, who looks at Muskoka from the water, the air and the land, capturing its many moods. With these special images to stir your own private memories of Muskoka, I'm sure you'll feel like I do – "you will always want to be here."

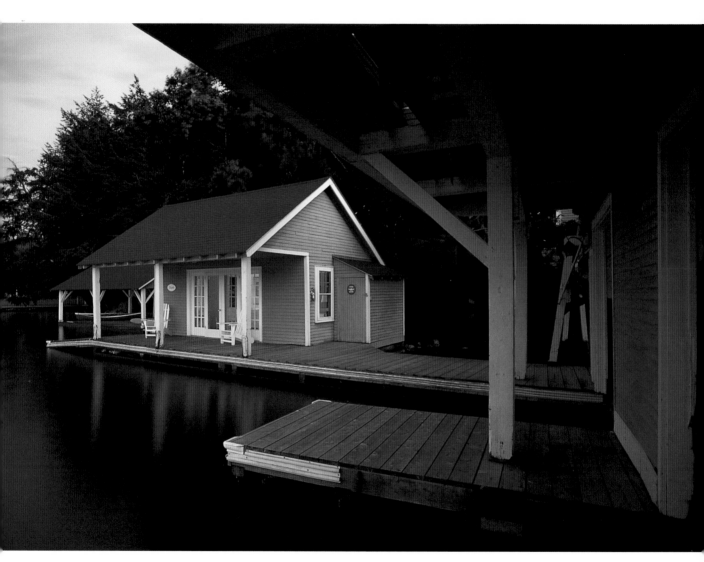

A guest cabin at Lake Joseph

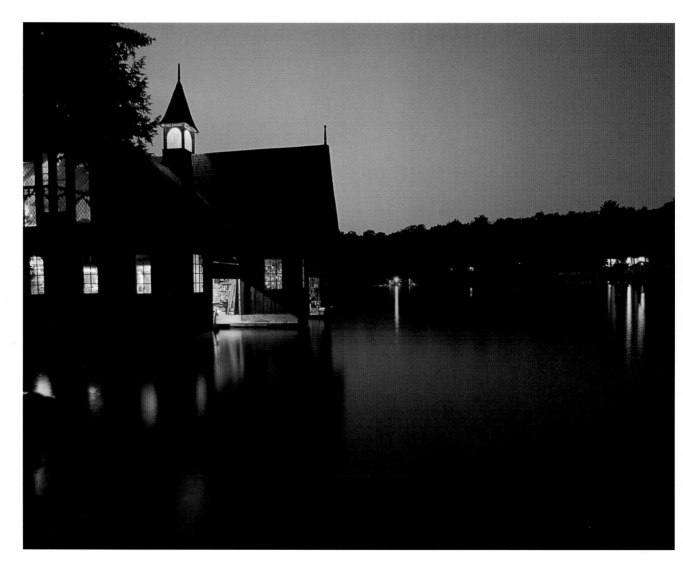

Night lights near Mortimer's Point, Lake Muskoka

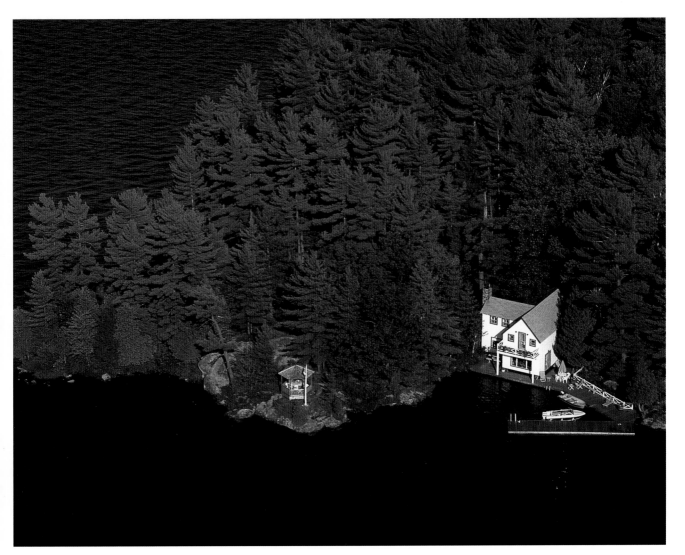

Horseshoe Island, Lake Muskoka

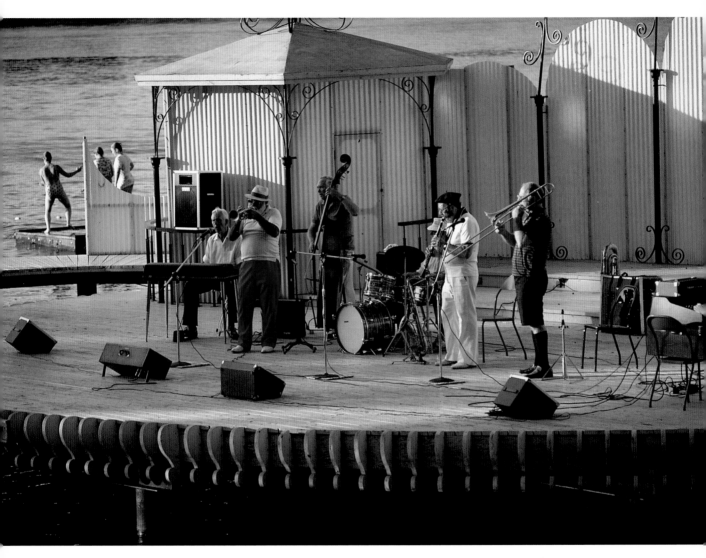

Gull Lake bandstand

A FIRST GLIMPSE

Travelling north to Muskoka from the more populated urban centres in the south, the first hint you get of this wondrous rocky terrain comes just beyond the Severn River. Here you see slabs of rosy granite rising from the ground on either side of the highway. Soon you reach Gravenhurst, the most southerly of Muskoka's towns and known as the "Gateway to Muskoka."

Like many Ontario towns, Gravenhurst has reinvented itself many times since it was first settled. In the mid–1800s, when it was known as Sawdust City, seventeen sawmills ringed Muskoka Bay. The bay was so jammed with logs, you could walk across them from one shore to the other. Logging continued to be big business. All over Muskoka, ancient pine trees, some of them over 100 feet tall (30 m), were felled to supply the building boom as settlers and tourists poured into the area.

Gravenhurst soon became a busy tourist hub, a meeting place of train and steamboat. The first train reached town in 1875, with a spur line to the Muskoka Wharf. There, passengers and goods were loaded onto steamboats and transported to resorts and cottages on the three lakes.

Gravenhurst is still the town with the big wooden gateway that first greets visitors, a harbinger of the area's attractions. Many visitors come directly to

Bethune Memorial House, Gravenhurst

Sagamo Park, the dockside berth of the RMS *Segwun*. The park is also home to a steamship–era museum, a local artists' gallery, and a weekly farmers' market. Every summer, handsome old steamers and mahogany launches line the dock for the Antique and Classic Boat Show.

The town's permanent population of 10,000 swells to 26,000 in summer, when cottagers take up residence, and activities like Music on the Barge and the Summer Theatre Festival start up again. Nestled between Lake Muskoka and the smaller Gull Lake, Gravenhurst has the sturdy Victorian charm of solid–brick stores and gingerbread–trim houses. Among the historic land–marks worth visiting are the newly restored Opera House, home to profes–sional summer theatre, and Bethune Memorial House, the birthplace of Canada's most famous doctor, Norman Bethune.

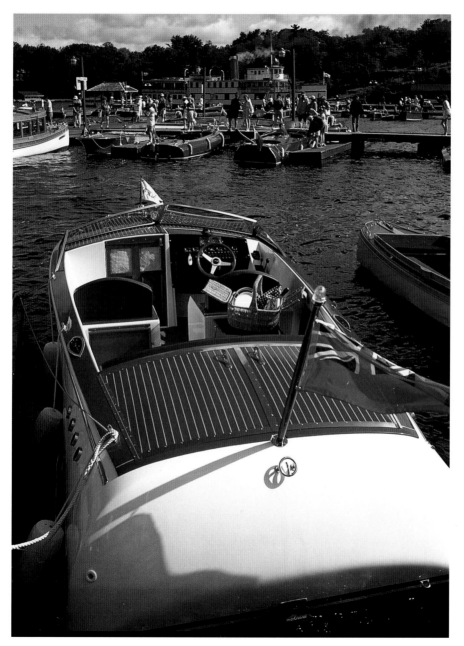

Antique Boat Show at Sagamo Park, Gravenhurst

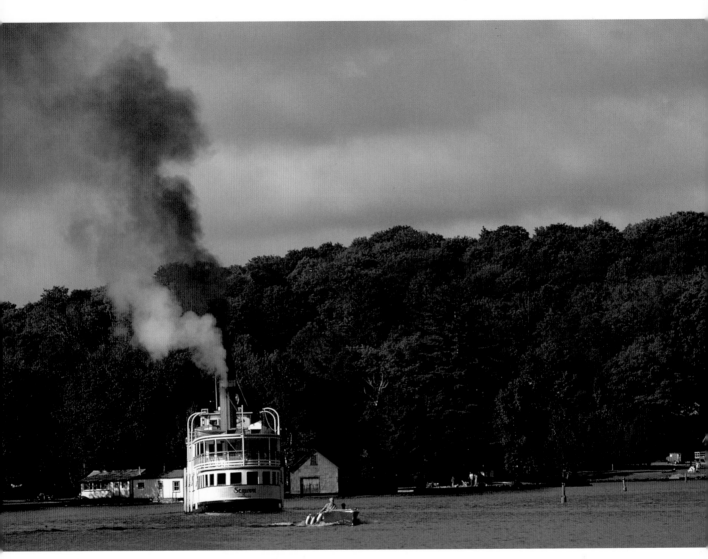

RMS Segwun *steaming along the Indian River*

THE SEGWUN

It's hard to look at the *Segwun*, Muskoka's handsome old steamboat, without imagining the steamboat heyday, when dozens of these elegant vessels plied the lakes. Picture the scene at Gravenhurst Wharf in about 1912, when three or four steamers would line up to meet the famous *Muskoka Express* train from Toronto. Also jockeying for position at the wharf would be private steamboats belonging to wealthy cottagers. These were usually driven by the family boat chauffeurs.

Cottagers and hotel guests would crowd onto the wharf, where everyone scrambled about identifying steamer trunks to ensure they were loaded on the correct boat. Adding to the clutter were pet birds in cages, wicker baskets filled with linens, and crates of food staples. It was not unusual to find a tethered cow amid the confusion, since families often brought a cow to supply fresh milk at the cottage.

By this time, 5,500 tourists could be accommodated in a variety of Muskoka hotels and boarding houses. Some of the more elegant among the crowd swishing about the wharf were headed to hotels like the Beaumaris and the Royal Muskoka. Wearing long, starched white dresses with cinched waists, the women carried parasols to keep the sun off their faces. The men looked even

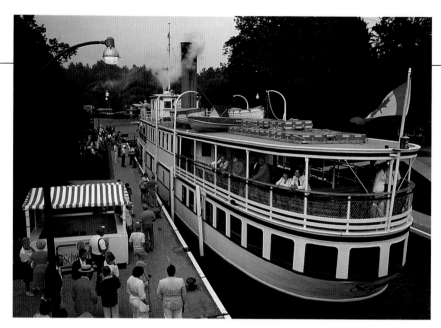

At the Port Carling locks

more uncomfortable in their white flannel pants and tight–collared shirts. But, discomfort ignored, they happily boarded the steamboat, knowing that the long journey from the city was nearing an end.

Today, when the *Segwun* circles the lakes, blowing her haunting whistle, everyone feels a nostalgic thrill. Cottagers wave from their decks and children race to the water's edge to watch her pass. She is still cruising today because of a group of steamboat lovers who persisted in their mission to put her back into operation long after she was retired in 1958. Following years of effort and setbacks, she was relaunched in 1981, when she made her second maiden voyage on Lake Muskoka.

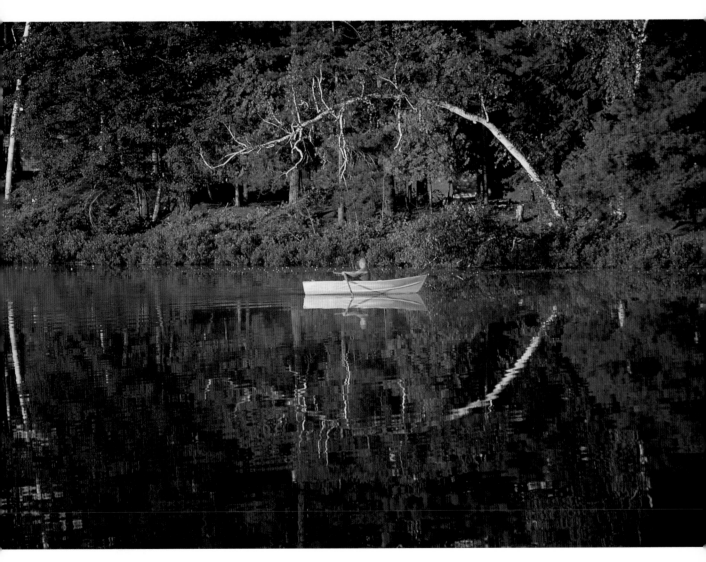

Old-fashioned boating

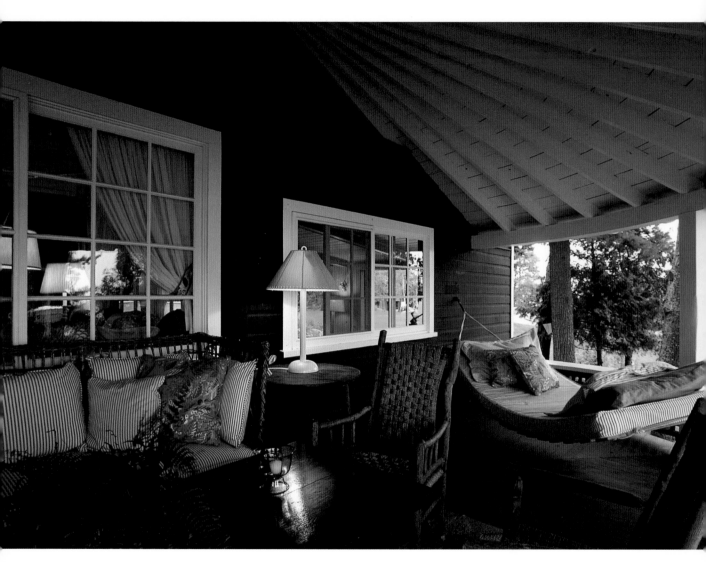

Cottage verandah at Beaumaris

COTTAGING

More than anything else, Muskoka is cottage country. Scattered about the shorelines of the lakes and rivers are all kinds of summer homes, ranging from rustic cabins lit by coal–oil lamps to opulent mansions with marble whirlpools. These country retreats, whether humble or grand, evoke the same feelings. Time and again cottagers will say, "My cottage is the one place I feel emotionally attached to."

Cottaging is a state of mind – it means escape, relaxation, memories. The cottage is where we kick off our city duds and while away the afternoons in rope hammocks. Cottagers generally agree that everyone who spends golden childhood summers at a cottage will want the same for their children. In this way the tradition passes from one generation to the next.

The first cottagers came to this northland to escape. At the turn of the century, the city was an unhealthy place in summer, full of coal smoke and disease. So families with the financial means just packed up and moved house. Much was made of the restorative powers of the pure, clean air; many believed that pine trees gave it an invigorating, curative quality. Certainly, being in Muskoka provided relief for hayfever sufferers, as ragweed had not yet reached the area.

Summer still life, Lake Joseph

In the 1879 *Guide Book to Muskoka*, the tourists – as cottagers were then called – were referred to as "those birds of passage, who, like swallows, annually cool themselves by a migration to our northern fastnesses, and depart refreshed." In the years before roads were built, they departed by the first of September, refreshed and ready for winter somewhere else.

Today, the cottage season traditionally falls between two long weekends. It begins with the May 24th weekend (the celebration of Queen Victoria's birthday), when the cottage is opened up and readied for summer. Then, on Canadian Thanksgiving weekend in October, families return. They gather to feast on turkey and pumpkin pie, warm themselves before wood–burning fireplaces, collect brightly coloured fallen leaves, and to do all the dreaded closing–up chores before bidding goodbye to the cottage for another year.

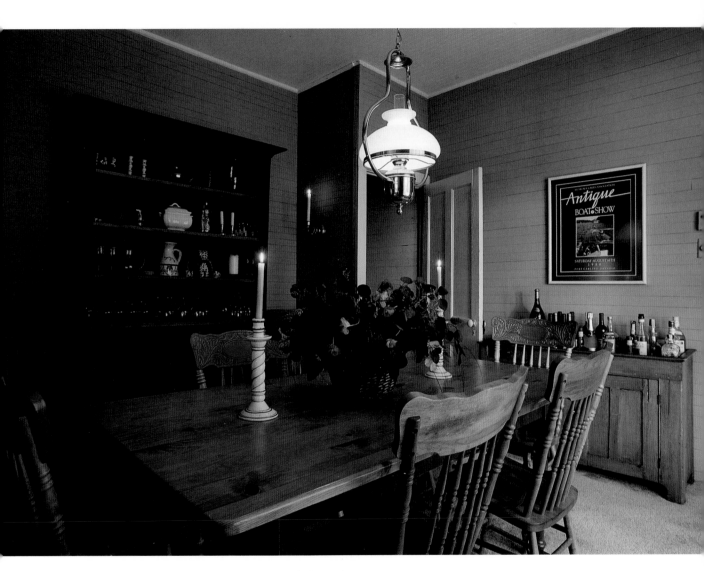

Milford Bay dining room

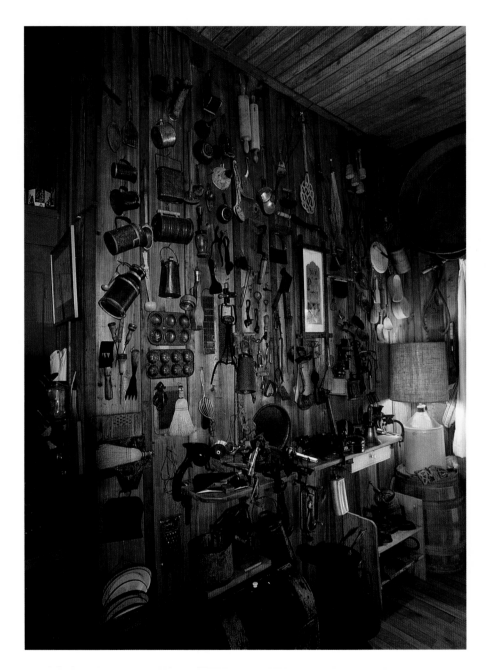

Kitchen wall,
Lake Rosseau

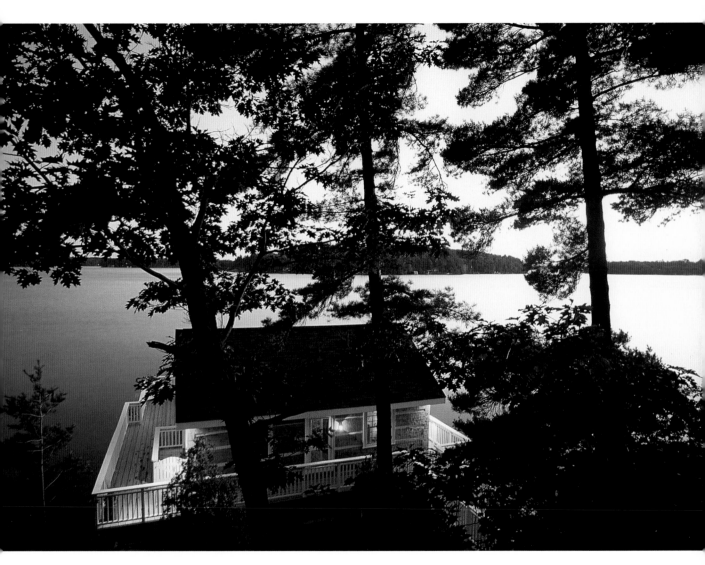

The boathouse viewed from the cottage deck

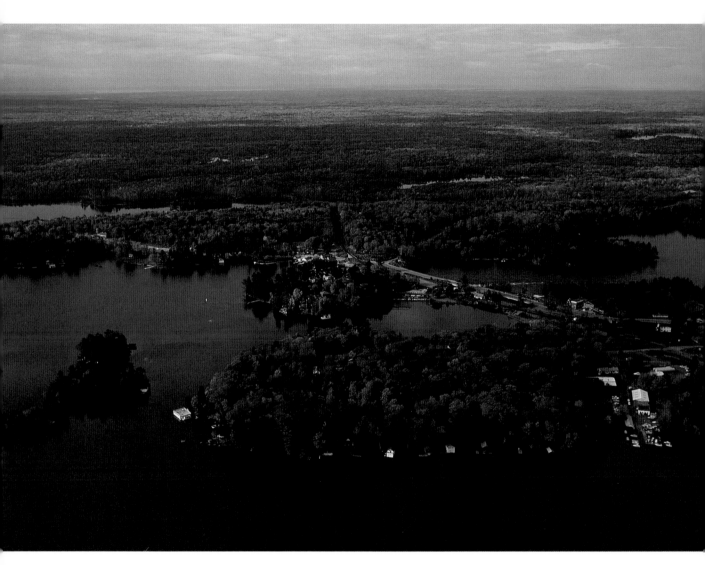

Bala, water and bridges

BALA

The tiny town of Bala grew up on a spit of land at the place where Lake Muskoka tumbles into the Moon River. It was first settled by a Scot, Thomas Burgess, who set up a sawmill in 1868 and named this town after the town of Bala in Wales. It was a sort of one-man town at first, with Burgess also running the post office, general store, blacksmith shop and supply boat. But, in later years, the man who really brought fame – and an aura of fantasy to Bala – was Gerry Dunn.

In 1929 Dunn, a pharmacist from Bracebridge, bought an ice-cream parlour on the main street. At the back was a little open-air dancehall, and on Saturday nights the piano player from the Windsor Hotel would come to play. But it was too small, so over the next few years Gerry Dunn kept expanding. In 1942 he built an immense ballroom, a pavilion with an enormous deck overlooking Lake Muskoka. The front of the building was a restaurant with a 60-foot-long (18 m) ice-cream counter where foamy choco-late milkshakes were served up. Dunn's never did have a liquor license.

Throughout the forties and fifties all the big-name bands played here. Posters tacked up everywhere announced coming attractions. (Gerry later admitted he offered gifts to the restaurant and store managers so they

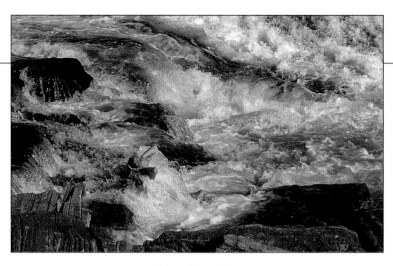

Moon River Falls

wouldn't take his posters down.) And on the highway just outside
Gravenhurst, he put up a huge billboard that proclaimed: Dunn's Pavilion,
Bala – Where all Muskoka Dances.

In 1950 Bala was the smallest town in Canada, with only 370 year-round
residents. But you'd never have guessed it on a Saturday night in July, when
2,000 people would crowd into Dunn's Pavilion. They came, dressed in their
summer finery, by boat and by car, lured by big names such as Louis
Armstrong, the Dorseys, Glenn Miller, Stan Kenton, Guy Lombardo, and Les
Brown and his Band of Renown.

Gerry Dunn gave up the business in 1962, and the dance pavilion has
changed over the years since. Now called The Kee, it's still a dancehall, but the
music and the dancers are different. All that's left of the big-band era are
charming memories of the days when all Muskoka danced at Dunn's.

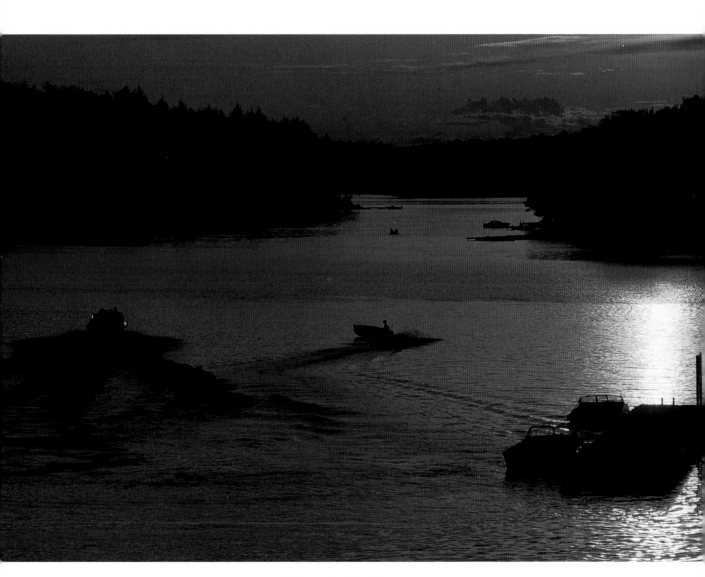

Dusk on the Moon River

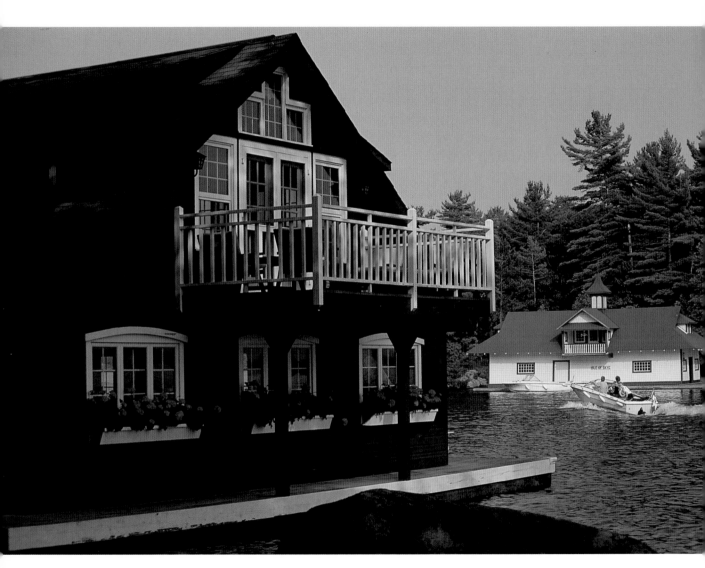

Boathouse neighbours on Lake Muskoka

BOATHOUSES

The first thing you notice when cruising the Muskoka lakes is the intriguing houses built on the water and supported by underwater cribs and beams. At water level they shelter the boats bobbing in their berths, and up above they provide quite sumptuous living quarters. Certain architectural details are particular to Muskoka boathouses, which tend to be more fanciful than cottages. Gables, turrets, cupolas, scrollwork under the eaves, Juliet balconies, and fancy-cut shingles adorn them. And every one of them has windowboxes spilling over with colourful annuals.

Boathouses were first constructed to shelter private steam-launches. The ultimate symbol of wealth, some of these lavish launches were 40 feet long and had canopied roofs. To accommodate them, boathouses were designed with long slips and tall, pitched roofs. And because the engines were stoked with wood or coal while the boat was in its berth, the ceilings were covered in tin, and smokestacks were cut into the roof. Some of these old boathouses still exist in modified form, though many have burned down over the years.

The second storey was initially intended to house staff, but today the space is used in various ways, from dormitory-style accommodation for the children to opulent guest rooms. And for many cottage families, the

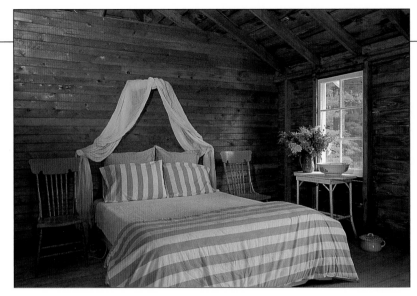

Lake of Bays boathouse bedroom

boathouse has become a private retreat for Mom and Dad, who say, "Once you have fallen asleep to the lapping of water and awakened to sunlight dancing off the lake, it's hard to sleep anywhere else."

In recent years, building by-laws for boathouses have changed almost yearly. At one time, new two-storey boathouses were not allowed at all. This caused much dismay among architects and builders who specialize in replicating the old Muskoka style. Cottagers also believe that boathouses give the Muskoka lakes a special character. "You don't find these structures anywhere else in the world," they point out. "As part of the heritage of Muskoka, they should be treasured and preserved."

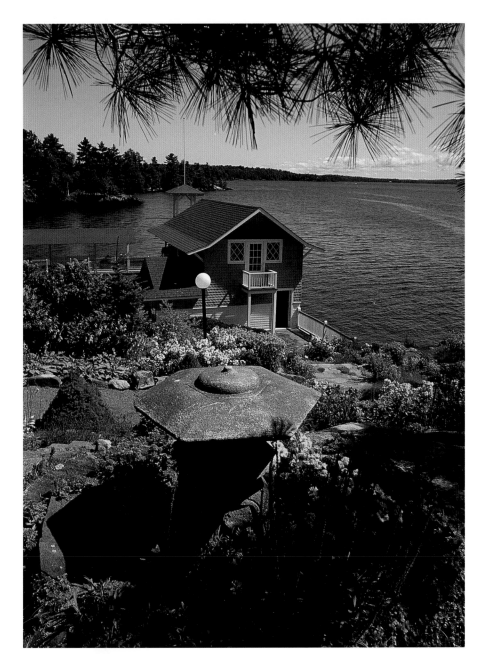

Llanlar,
Lake Rosseau

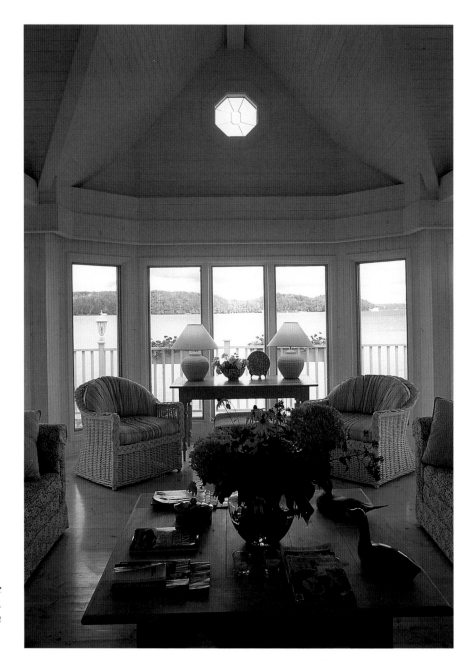

*Boathouse
living room,
Lake Rosseau*

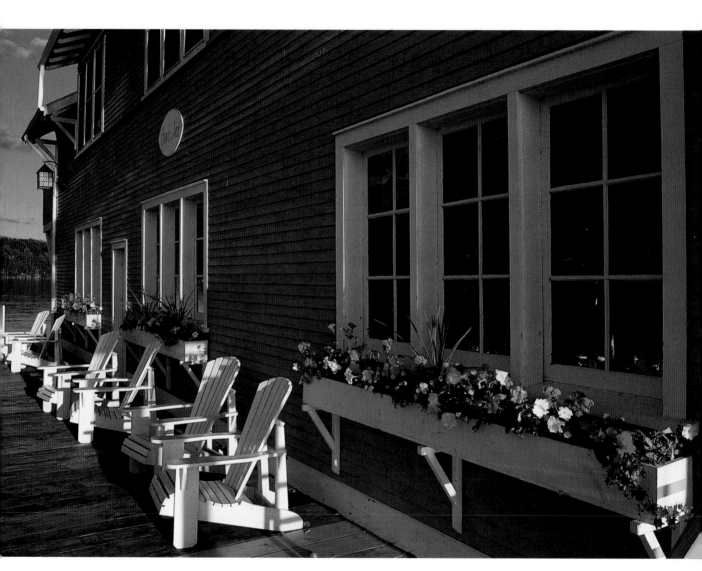

Afternoon sun on Lake Joseph

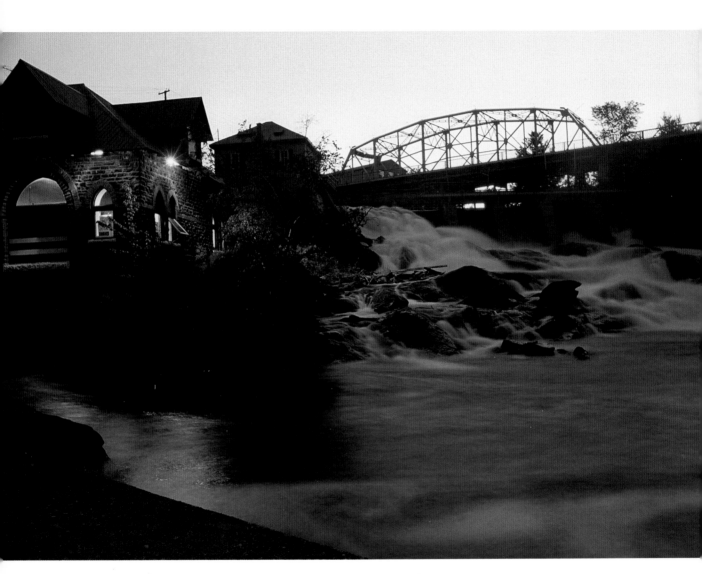

Waterfalls at Bracebridge

BRACEBRIDGE

At first glance, Bracebridge looks like any other Ontario town. It has a downtown row of handsome brick stores, a memorial park on the main street, and a sprawl of shopping malls on the main highway. But beneath this somewhat ordinary exterior is a creative heart.

Many of the new citizens who have made Bracebridge the fastest-growing town in Muskoka are artistic folk living in restored farm properties on the outskirts of town. Potters, weavers, glass-blowers and ironworkers have gathered here because, as potter Jon Partridge says, "It's a nice place to live and to raise a family." They also enjoy an active, supportive community.

For one thing, there's the Muskoka Autumn Studio Tour. Every September since 1978, this popular weekend event has welcomed the public into the artists' studios to watch them working at their easels, potter's wheels, and weaving looms. There's also Muskoka Arts and Crafts, a district-wide organization of 300 artists and craftspeople that has its home in the Chapel Gallery in Bracebridge next to Woodchester Villa. The gallery, a reconstruction of the town's original pioneer Presbyterian Church, holds regular exhibits of members' work.

And every July, there's a huge summer arts and crafts show, held in Annie

Muskoka artist Mieke Martin's studio garden

Williams Park, that draws over 200 exhibitors from Muskoka and other parts of Canada. The setting – a lovely riverside park shaded by tall pines – provides a perfect backdrop for the artists' creative displays.

Final evidence that this town has a fanciful soul is Santa's Village, found just outside of town. Here, Rudolph pulls a roller coaster, Mrs. Claus bakes cookies, and the *Candy Cane Express* chugs across the 52-acre (21 ha) park. Bracebridge is Santa Claus's summer home. The town fathers who dreamed up the idea back in 1955 knew that Bracebridge offered the perfect location – on the 45th parallel of latitude, exactly halfway between the equator and Santa's winter home at the North Pole. The jolly old man has been summering here ever since!

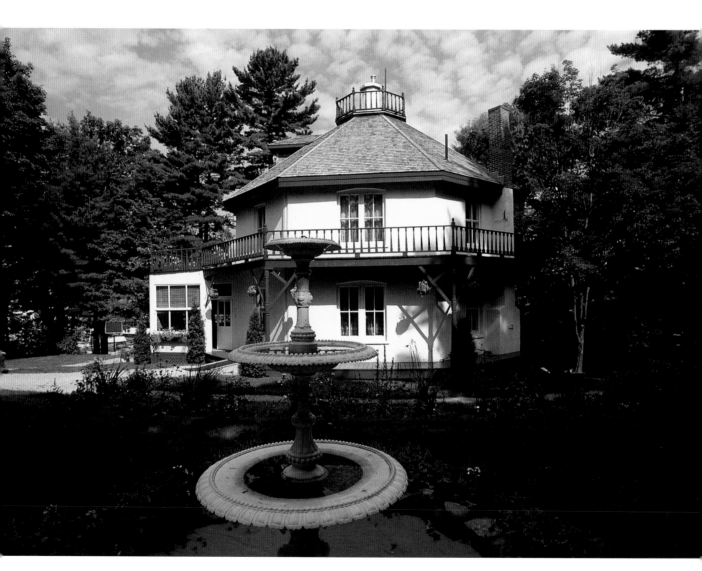

Woodchester Villa, Bracebridge

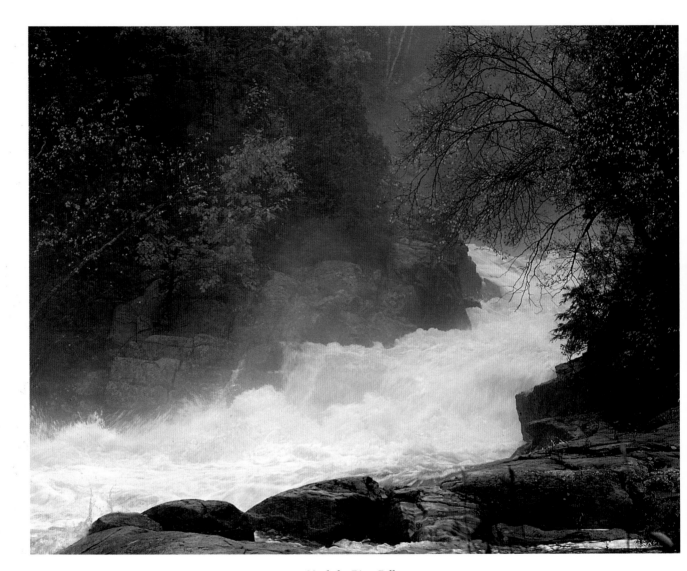

Muskoka River Falls

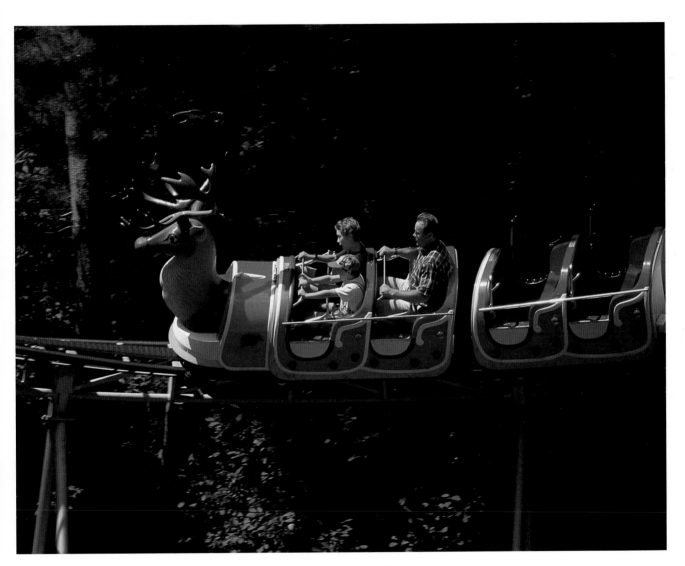

Santa's Village near Bracebridge

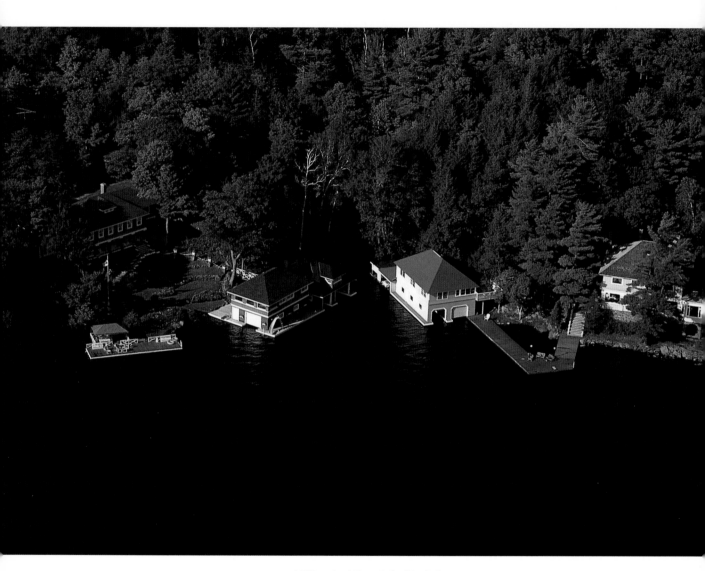

Millionaires' Row, Lake Muskoka

MILLIONAIRES' ROW

Of all the memorable places in Muskoka, the channel on Lake Muskoka known as Millionaires' Row is probably the one visitors find hardest to forget. It is so named because of the luxurious cottages and boathouses that line the channel between two islands near the village of Beaumaris. A boat tour of the narrow channel is Muskoka's answer to the celebrity house tours of Hollywood – except that these cottagers are not celebrities. Most of them are quietly rich Americans whose ancestors came here, mainly from Pennsylvania, at the turn of the century and built these elaborate stone–and–wood mansions.

The cottages are immense, rambling structures, several storeys high, spread out along the rocky shore. Stone walkways lead to the water's edge. There is usually an assortment of outbuildings as well – icehouses, laundry rooms, gazebos. These compounds were built when entire extended families came to Muskoka for the whole summer. Usually that meant Mom and the kids, grandmothers, grandfathers, aunts, cousins – and a bevy of servants to keep the household running. The boathouses, which had upper living quarters, were designed to match the cottage and were painted grey, green or brown to blend with the scenery.

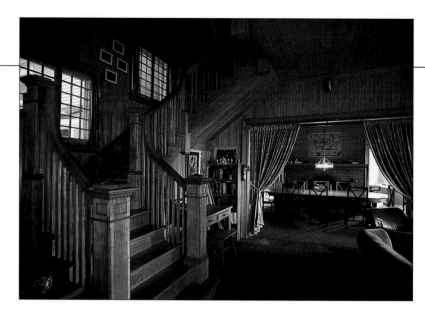

1895 cottage at Beaumaris

Much of the area's cachet began when the Beaumaris Hotel opened in 1883. An Englishman, Edward Prowse, turned his three-storey home into a resort and named it Beaumaris after a village on Anglesey Island in Wales. An instant success, it was a glamorous place that grew to include new wings with rooms for two hundred guests and a 220-foot (67 m) verandah that wrapped around two sides. Guests played croquet and lawn tennis during the day and whiled away the nightime hours to orchestra music in the dance hall. The hotel attracted a fashionable crowd, many of them Americans who fell in love with the area. Later, after the hotel burned down in 1945, they stayed on in the lavish summer homes that still stand on Millionaires' Row.

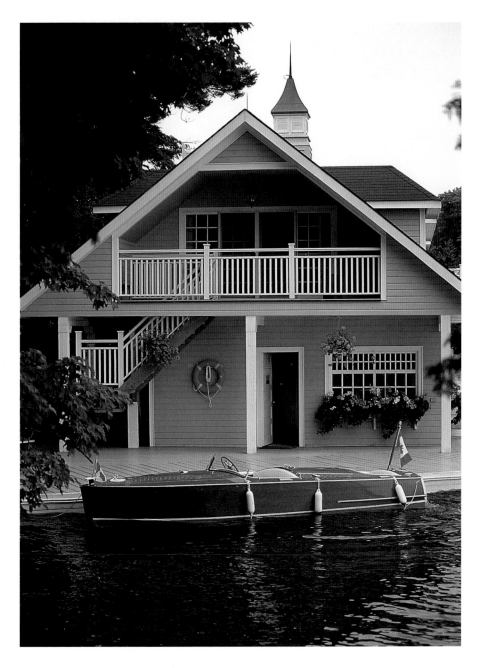

*Boathouse on
Millionaires' Row*

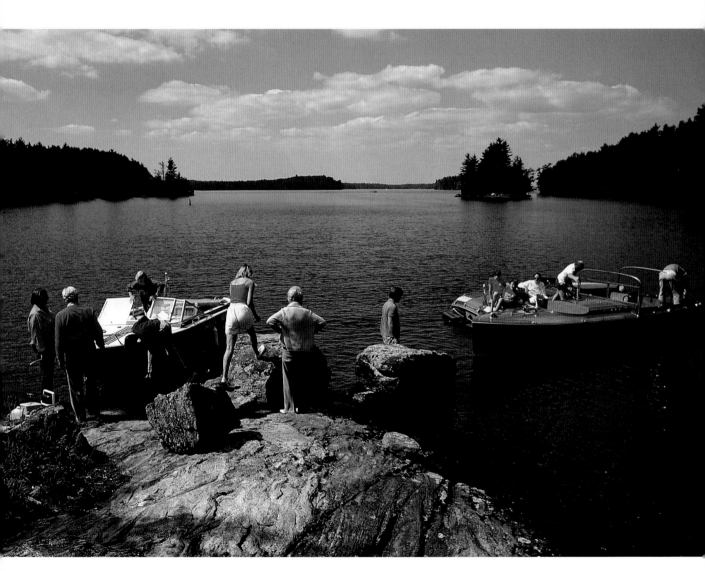

Gathering for a picnic

THE BOATING TRADITION

Ditchburn, Minett, Greavette, Duke – boat names as familiar to anyone in Muskoka as the names Ford or Chevrolet are to anyone who drives a car. Herb Ditchburn, Bert Minett, Ernie Greavette and C.J. Duke were hard-working boatbuilders in the 1920s and 1930s, when Muskoka was the wooden boatbuilding capital of North America. Some of their finely crafted vessels survive and can be seen on the lakes today.

Boating began in Muskoka as a necessity. The dense woods and rocky terrain made land access difficult, and the waterways provided easier trans-portation. First, rowboats appeared on the lakes, some with two or three sets of oars for family togetherness. Old-timers still recall rowing miles across the lake to collect fresh eggs and milk from a local farmer. And at the hotels, wooden skiffs, along with canoes and sailboats, were available for guests.

Commercial steamboats began regular lake runs in the 1870s, but some cottagers, frustrated by the erratic steamboat schedules, bought their own steam yachts. Gasoline engines followed, and by 1915 there were over 300 gas-powered motorboats on the lakes. Most of the finely crafted mahogany launches were built in the 1920s and 1930s. The builders used only the best imported mahogany and then coated it with layers of special varnish;

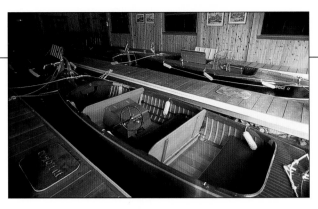

A collector's boathouse on Lake Muskoka

expensive leather covered the seats; shiny brass and chrome added dazzle to the fittings. Racing these gasoline-driven launches was a favourite pastime, too. The Muskoka Lakes Association ran powerboat races from 1912 until the beginning of the Second World War.

Throughout the sixties and seventies there was little interest in these old boats. Many of them had rotted and were taken out to the middle of the lake to be sunk, or were simply abandoned in storage sheds. One old steam yacht met a worse fate. It became a hot dog stand called The Ark. But these old treasures were rediscovered, a revival took place, and owning a genuine Muskoka boat was once again a symbol of prestige. A handful of Muskoka cottagers collect antique boats. Inside their boathouses are row upon row of them – polished, pristine, and tightly tethered with thick white ropes. The passion for these old boats has spawned a new industry, the restoration of vintage craft. Now, at Duke and Greavette, the two remaining boatbuilders, the workshops are humming once more.

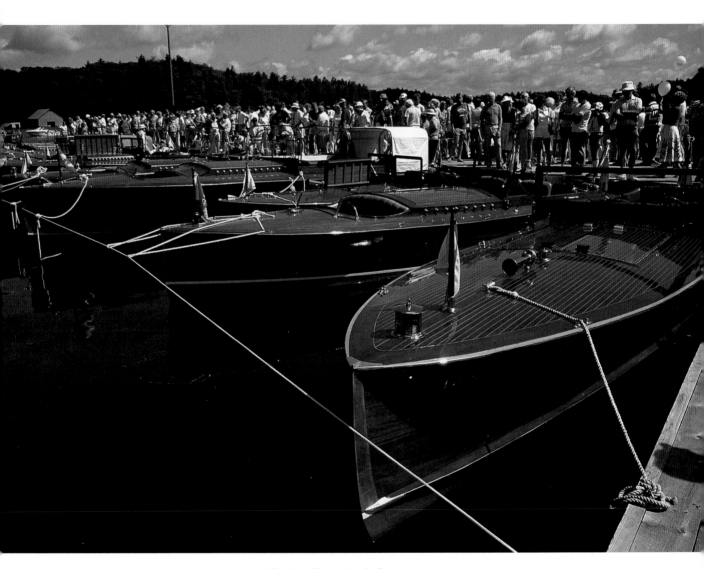

The Boat Show, Port Carling

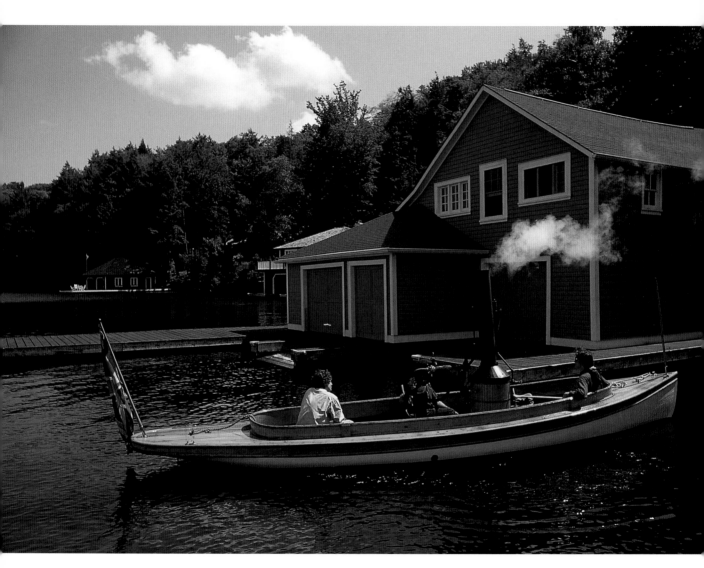

Antique steam launch, Lake Joseph

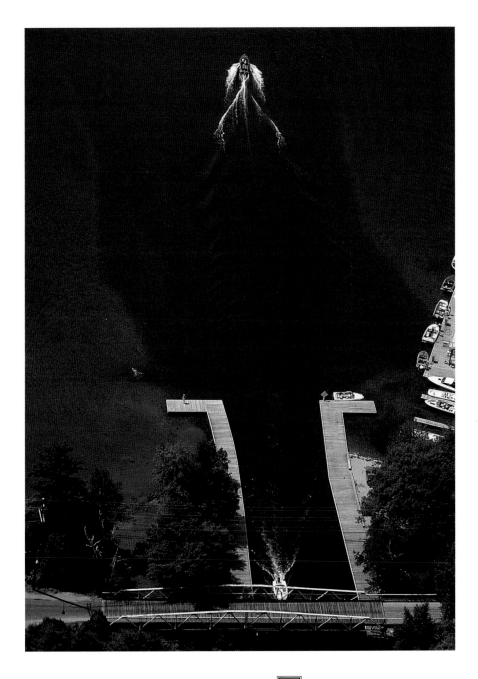

Port Sandfield

Sarah *for sale, Port Carling*

PORT CARLING

On weekends in midsummer this little town known as the "Hub of the Lakes" gets so crowded with shoppers that locals complain, "It's just like New York." Anyone looking for a parking space might agree. Port Carling has one main road that dips down to the bridge on one side of town and up on the other. But even at its most crowded, you can always find a quiet spot somewhere on the grassy island between the two locks.

The Muskoka Lakes Museum is located here. Opened in 1967 as a Centennial project, it has wonderful displays depicting the settlers' life and honouring the town's boatbuilding heritage. The most popular boat ever built here is the dippie, or dis-pro, the disappearing-propeller boat invented in Port Carling in 1914. Outside, a spreading lawn offers shady nooks for watching the boats line up to pass through the locks joining Lakes Muskoka and Rosseau.

Before the locks were constructed, a series of rapids tumbled between Lake Rosseau and Lake Muskoka, making boat traffic impossible. One of the early navigation entrepreneurs in the district was determined to open up the three big lakes for steamboat travel, so he prevailed upon the Minister of Public Works to get these locks installed. The locks were opened in 1871, the minister was John Carling, and the town was named after him.

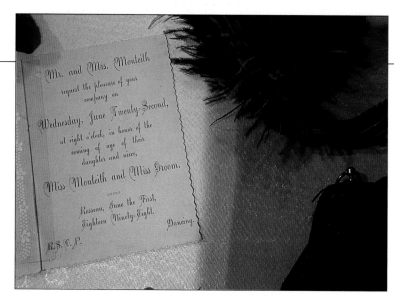

Muskoka Lakes Museum, Port Carling

Before it became Port Carling, the settlers called this area Indian Village. About a hundred Ojibwa lived here. After they moved on, further north to Parry Island on Georgian Bay, another group arrived in the 1880s, the Mohawks from Québec. They settled on the Gibson Reserve near Bala, and for many years spent summers on the riverbank in Port Carling. Their homes were small huts with hinged wooden shutters that pulled down to convert them into storefronts in the daytime – shops where they sold their handiwork. Today, their porcupine-quill baskets and beaded mocassins are still treasured in many old cottages and can be seen in displays at the museum. Only one of the original shops remains – Roads Craft Shop, just across from the small locks.

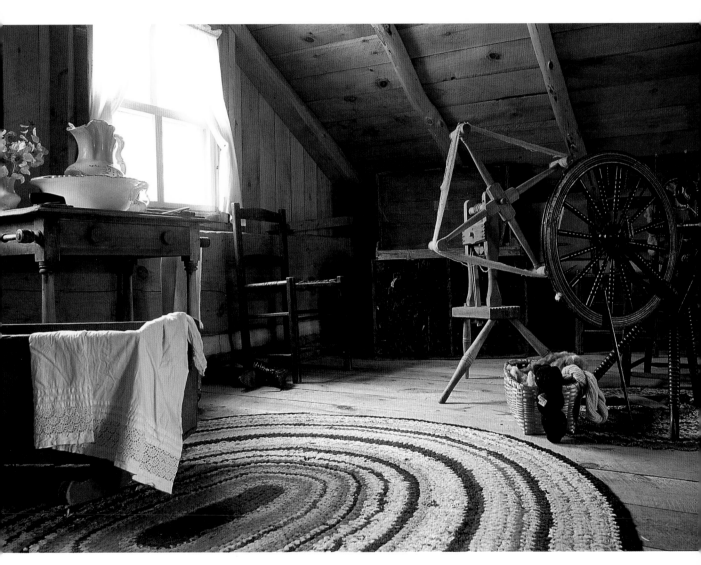

Pioneer exhibits, Muskoka Lakes Museum, Port Carling

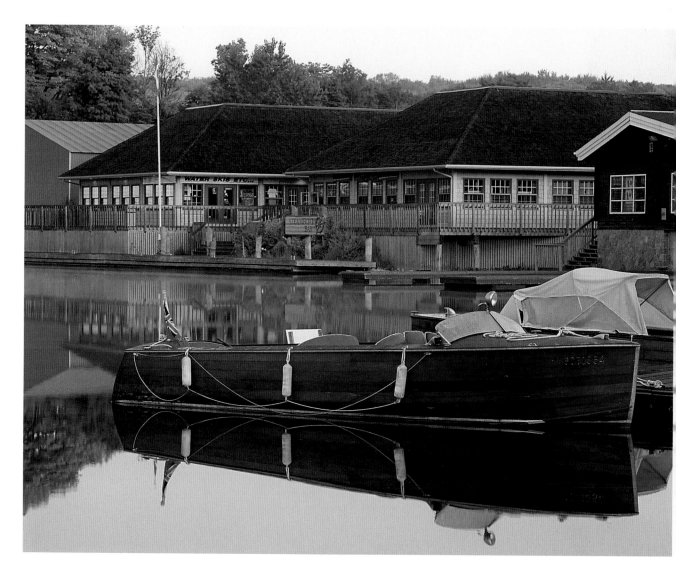

Steamboat Bay, Port Carling

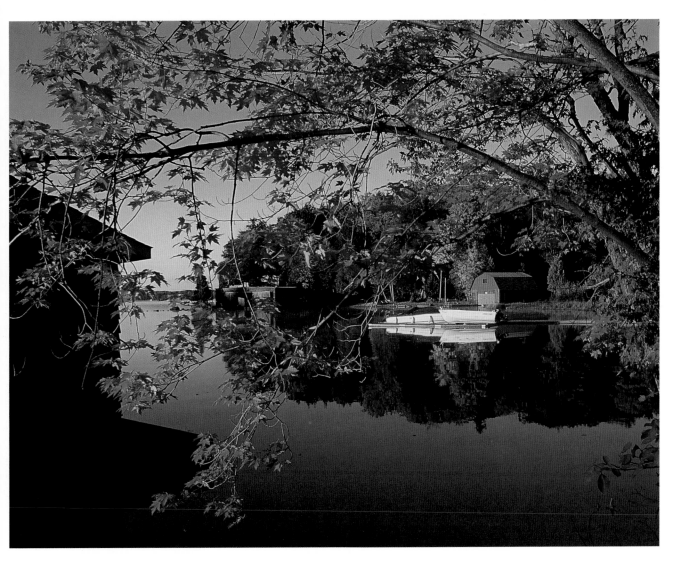

Autumn reflections

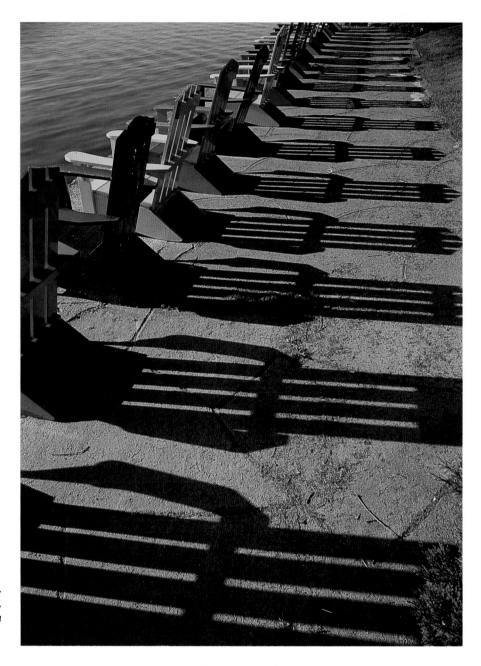

Chairs and shadows,
Clevelands House,
Lake Rosseau

CLEVELANDS HOUSE

The Clevelands House story is one of those heartwarming tales in which determination succeeds against all odds. Its evolution as a hotel is not unlike others, but the ending is different. Most Muskoka hotels built around the turn of the century didn't survive – they either burned down or closed down. But Clevelands House remained, grew, and changed with the times. It celebrated its 125th anniversary in 1994.

The story begins in 1869 when Charles and Fanny Minett came to Muskoka as settlers to take advantage of the free land grants offered by the government. They were from England and had lived for a while in Toronto, but their son Bert suffered from bronchitis, and their doctor recommended a move to a drier climate. Soon after they arrived at their 200 acres (80 ha) on Lake Rosseau, they put up a one-room cabin, christening it "Cleeves Land," after Bishop Cleeve in England.

The next year a lock was installed at Port Carling, opening up the lakes for boat travel. Campers and fishermen soon began arriving at the Minetts' homestead in search of a bed. The Minetts took them into their home, and as more tourists arrived, they added more rooms, until in 1883 they built a separate building that became the original hotel. When registering the

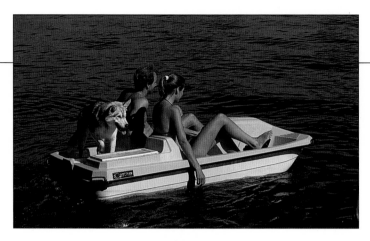

Pedal power

hotel, a clerk in the registry office omitted an "e" and wrote Clevelands House, and the name was never corrected.

After Charles Minett died in 1892, Fanny continued to operate the hotel successfully, adding a ballroom and enlarging the dock space with the help of her four sons. Son Bert, a cabinetmaker and one of Muskoka's legendary boat–builders, began by building boats on the property. In 1902 Fanny Minett passed the hotel on to another son, S.A. Minett. At that time the resort had rooms for 150 guests (at $2 a day) and, at the north end of the property, a tent colony was set up exclusively for young single men who preferred to rough it.

S.A. Minett kept the hotel running until 1953, retiring after he and his wife celebrated their fiftieth wedding anniversary. In its entire existence the hotel has belonged to only three families. Current owners Bob and Fran Cornell have owned it since 1969 – and Bob's affiliation with the hotel goes back to 1949, when he worked there as a bellhop.

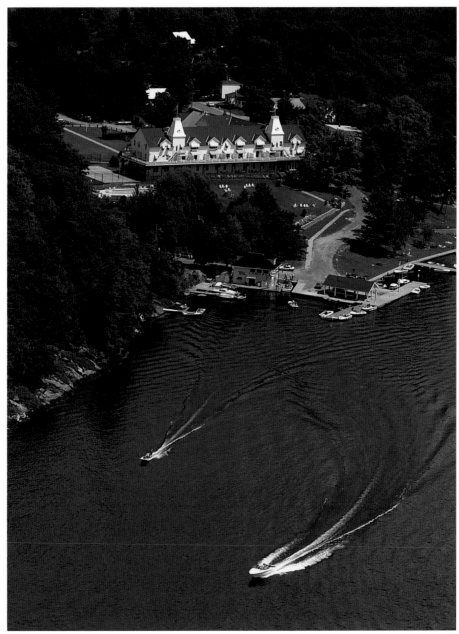

Windermere House,
Lake Rosseau

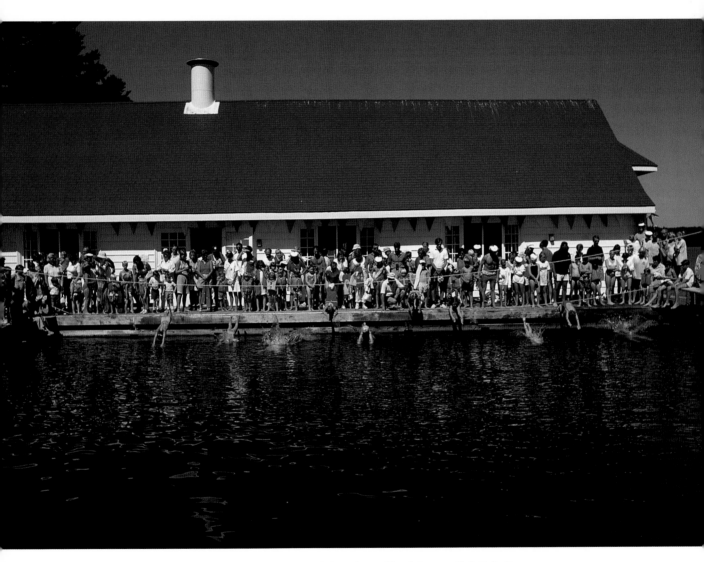

Regatta crowds at the Muskoka Lakes Golf and Country Club, Lake Rosseau

REGATTAS

Regattas have always been part of the Muskoka summer experience, but their true origins go back to Venice in the seventeenth century. The very first regattas were boat races held on the Grand Canal, and the word regatta comes from *rigettare*, Venetian dialect for "fight." In Muskoka, as in many lake districts, the regatta has been a cherished annual event as long as anyone can remember.

On a chosen day each summer, family members, wearing bathing suits and orange lifejackets, pile into boats and head to the regatta with a string of canoes and rowboats in tow. All the events are fiercely contested, pitting family against family, child against child. There's paddling, swimming, diving and rowing, not to mention tennis-ball tossing and inner-tube bobbing. Champions are born, hopes dashed, and trophies awarded.

Many associations hold regattas, but the oldest and most tradition-bound is the Muskoka Lakes Association (MLA) Regatta held every year at the Muskoka Lakes Golf and Country Club on Lake Rosseau. The association and the regatta were a hundred years old in 1994. The MLA is the oldest cottagers' association in Canada, and part of its mandate has always been to "promote aquatic and sporting events on the three lakes."

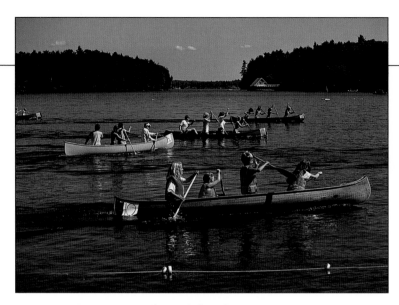

Canoe contest at the Muskoka Lakes Association regatta

The early MLA regattas were well-recorded society events held at the different hotels. The Toronto newspapers gave full accounts of the activities, noting the prominent guests and the steam launches in which they arrived: "Mr. and Mrs. Timothy Eaton were there with their attractive *Wanda.*" Back then, after a strenuous day of waterfront activity, everyone changed into evening attire and went to the regatta dance, a festive affair that beguiled the society editors. This regatta story appeared in an August 1894 Toronto *Globe*: "The annual concert was held in the evening. The banjo selections of Mr. Bert Kennedy were most cordially received. Mrs. Juliet d'Ervieux Smith sang in excellent voice, and Miss Ella Ronan, Mr. W.E. Rundle and Miss O'Grady also added greatly to the evening's entertainment."

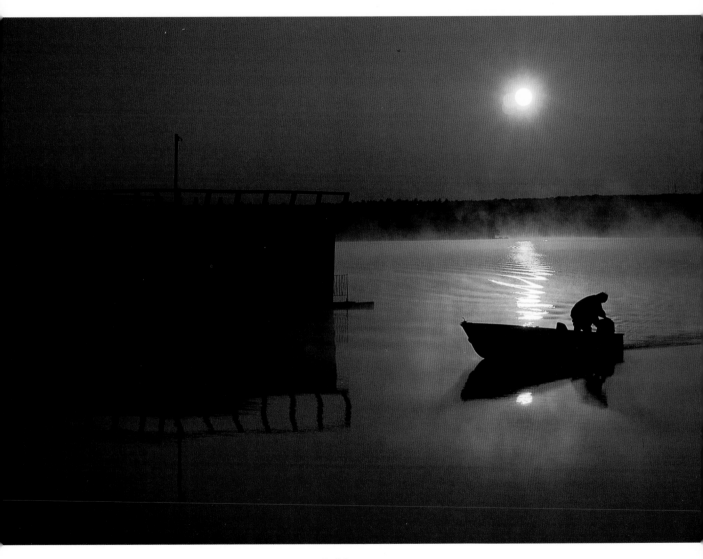

End of day

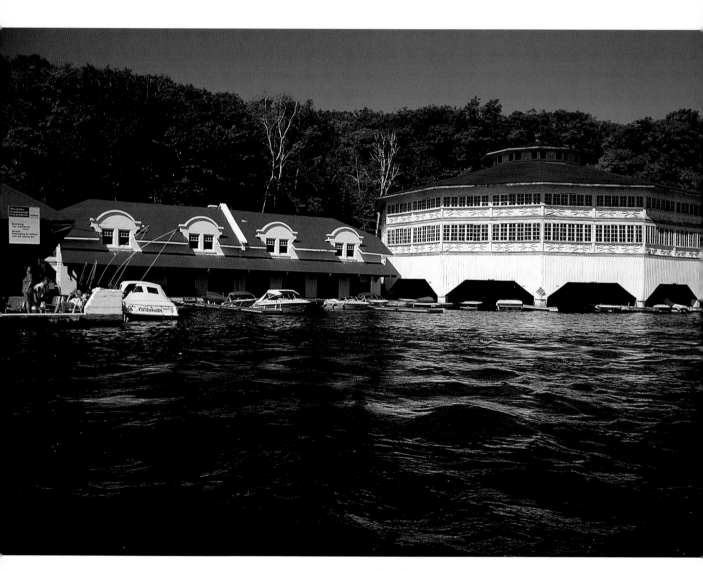

Bigwin Inn on Lake of Bays

BIGWIN INN

If ever a resort spelled glamour with a capital G it was Bigwin Inn on Lake of Bays. The island resort offered everything a pleasure–seeker (as tourists were often called) could possibly want. It opened in 1920, and for the following glittering decade the pleasure–seekers included royalty, Hollywood stars, and the very wealthy. The massive hotel with big white buildings and cherry–red roofs dominated the lakefront. The huge twelve–sided dining room and dance pavilion were constructed of solid concrete, because the owner, C.O. Shaw, was determined that his hotel would not meet the same fate as other Muskoka hotels that had burned down.

The central building had nine stone fireplaces, a library filled with leather–bound books, a doctor's office, a telegraph office, a beauty parlour where the women were gussied up for the formal evening festivities, and an enormous lounge surrounded by breezy verandahs. There were 280 guest rooms, enough to accommodate 700. Outside, covered walkways crisscrossed the grounds, leading to croquet lawns, bowling greens, clay tennis–courts and an eighteen–hole golf course.

Because the hotel was on an island, guests had to be ferried by private steamboat from Huntsville and later from across the lake at Norway Point.

Lake of Bays

They arrived with steamer trunks filled with summer finery (white tie and tails were worn in the dining-room), and often were greeted by the hotel owner himself. Shaw had made his fortune in the tannery business, but was also well known for his Anglo-Canadian Concert Band. They played in the hotel dining room and were reputedly one of the best concert bands in North America.

After Shaw died in 1942, Bigwin Inn was passed on to his daughter, who sold it a few years later. It changed hands a few times but never regained the popularity or the panache of its heyday in the twenties. Shut down permanently in the sixties, it is now a ghostly presence, sadly neglected but still intact, an ironic postscript to C.O. Shaw's intention to build a hotel that would stand forever.

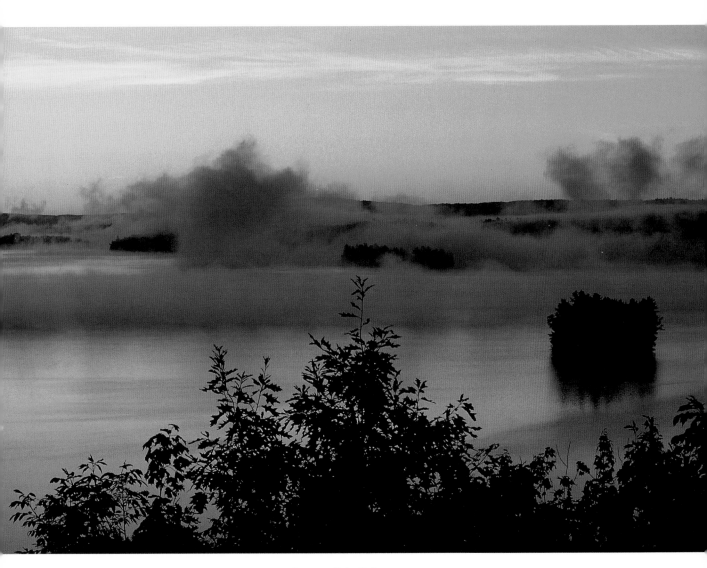

Dawn at Fairy Lake

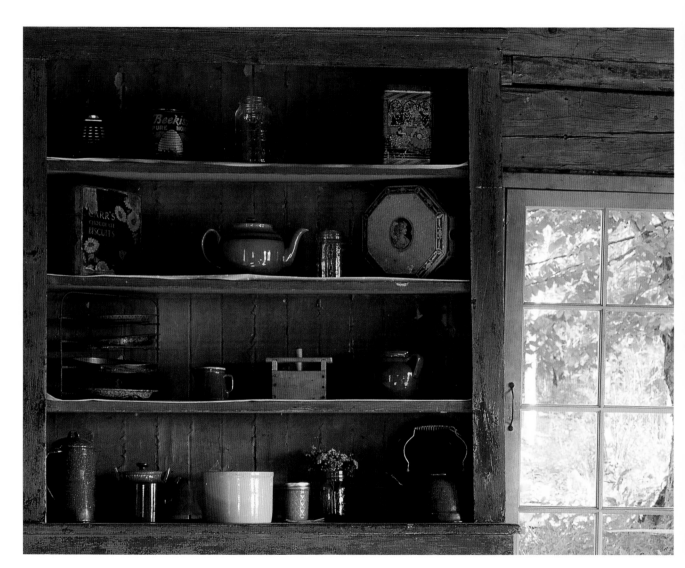

Muskoka Pioneer Village, Huntsville

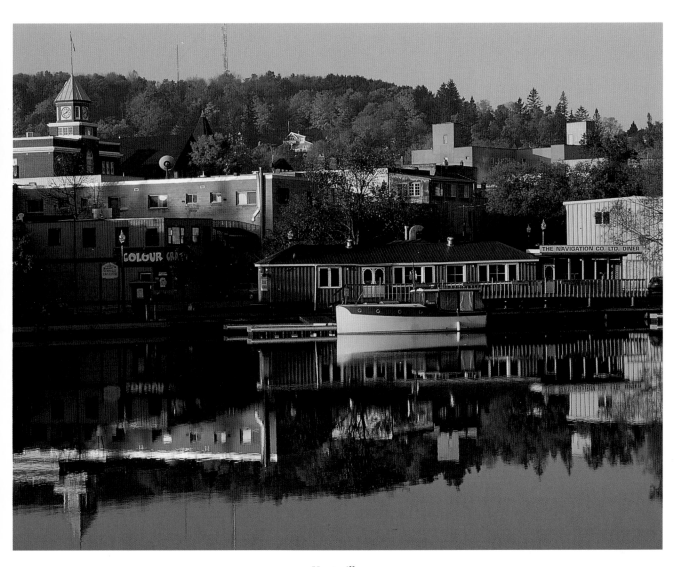

Huntsville

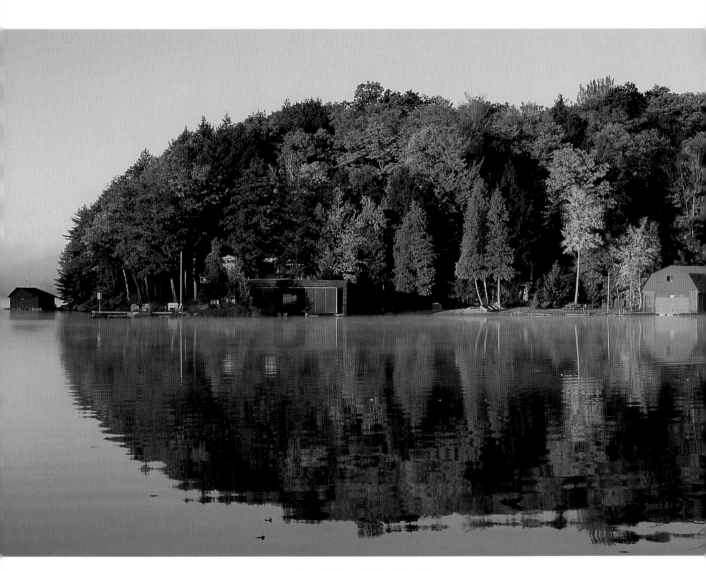

Scarcliffe Road, Lake Muskoka

MUSKOKA'S OTHER SEASONS

Cottagers tend to think the year begins and ends with summer. But Muskoka has other seasons, quieter times, when the crowds have left, the cottages are boarded up, and the boats hauled away for winter storage. It's during these seasons that the lakes return to the pace of earlier times.

Fall days are spectacular here. Dazzling red and gold leaves swirl across the shoreline, bright against the dark green of fir and pine. The water takes on a deeper tone of blue, shadows lengthen and the days turn cool. The scent of wood-smoke and fallen leaves fills the air. Overhead, migrating flocks of Canada geese fly in shifting V-formations, their noisy honking bidding Muskoka farewell. Fall fairs and farmers' markets bring the bounty of the countryside to the towns. The Cranberry Festival in Bala celebrates the luscious red berry with tours of the bog sites; hikers take to the trails leading into deep woods; golfers have the courses all to themselves. And, for one weekend in late September, an artists' studio tour bring hundreds of visitors back.

Come winter, the land is covered in a thick crust of snow. There's little life visible around the frozen lakes. Only the whoosh of cross-country skis and

the chirping of chickadees at someone's bird–feeder break the silence of a frosty winter morning. At Muskoka Pioneer Village in Huntsville, a Victorian Christmas is celebrated with carollers and horse–drawn sleigh rides. Then, in January and February, at the winter carnivals, there's noise aplenty when locals and city visitors come out for the dogsled races, Polar Bear dips, snowmobile events, and log–sawing contests. Ice sculptures line the main streets. Families, friends and neighbours gather around bonfires and drink hot mulled cider.

Spring brings the warming sun, longer days, the crunching breakup of the ice on the lakes, and maple syrup. Since pioneer days, "sugaring–off" has been a time of celebration. A host of maple festivals and pancake breakfasts are held throughout the region, giving all a chance to see how maple trees produce this sweet syrup – and to sample it. At Deerhurst Resort, the sap from a thousand trees is processed and bottled on–site, to the delight of guests.

Spring is also trillium season. The white woodland flower with three-pointed petals is Ontario's floral emblem. For a brief few weeks in May, before the trees leaf out, the trilliums spread like a white carpet across the forest floor. For cottagers returning in May, the sight of trilliums is a sure sign that summer will soon follow.

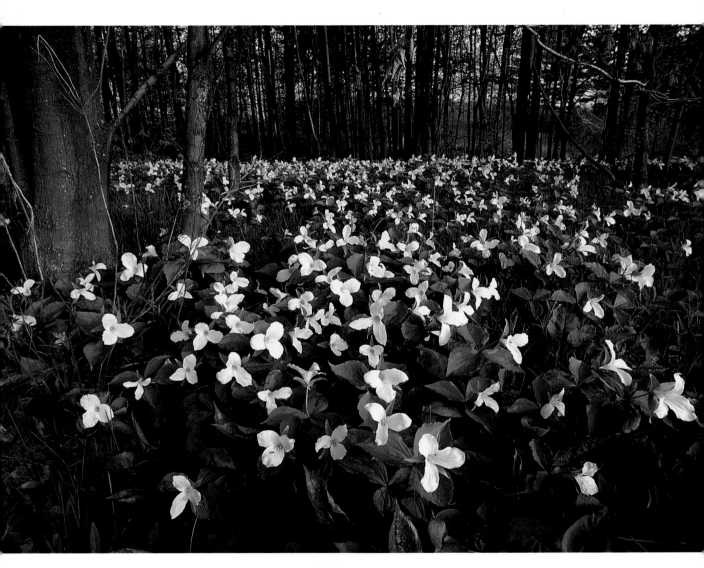

Trilliums

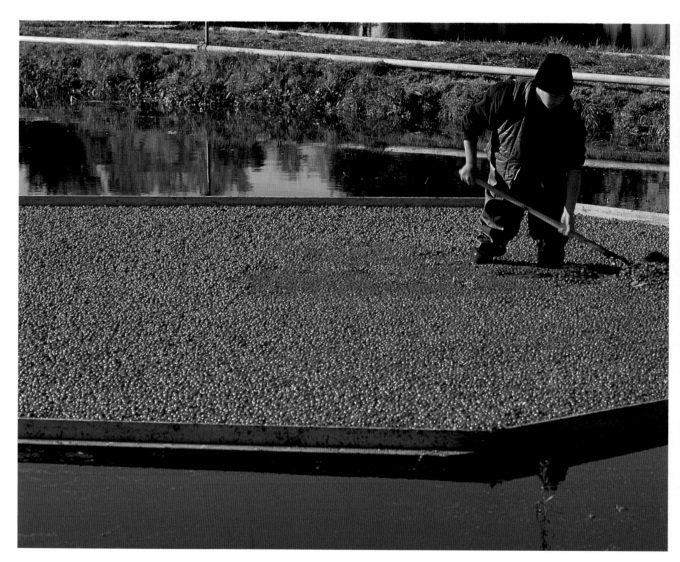

Harvesting cranberries on the Gibson Reserve

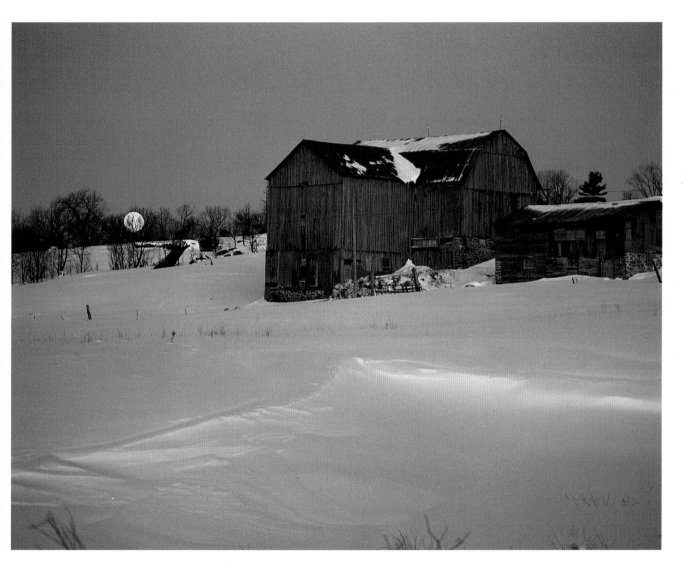

Winter moon

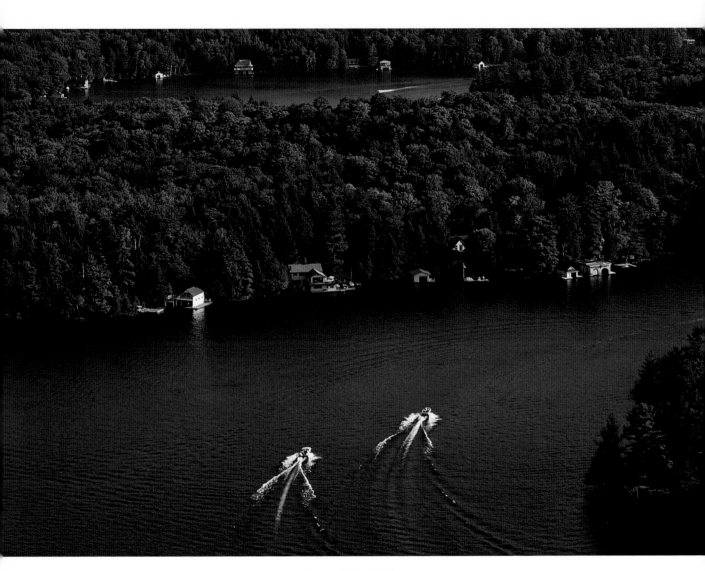

Lake Muskoka, a bird's-eye view

MUSKOKA DATEBOOK

1615 – Samuel de Champlain is the first explorer in Muskoka.

1828 – Fur trader Jean Baptiste Rousseau names lakes Rosseau and Joseph after his father, Joseph Rousseau.

1837 – David Thompson is the first explorer to map all three lakes.

1853 – Alexander Murray explores Mary, Fairy, and Peninsula Lakes, and Lake of Bays, and names them.

1858 – The colonization road is completed from Washago to Bracebridge.

1865 – The first boat is built in Muskoka by the Johnston brothers of Port Carling.

1866 – A.P. Cockburn launches the first steamboat on the lakes, a paddle–wheeler named the *Wenonah.*

1869 – The first hotel is built in Port Carling atop the hill and named the Polar Star.

1869 – Henry Ditchburn and his brothers settle in Rosseau and begin building rowboats and canoes for tourists at the Rosseau House Hotel.

1870 – Muskoka's first newspaper, the *Northern Advocate*, is transferred to Bracebridge from Parry Sound.

1870 – Port Sandfield is named after J. Sandfield Macdonald, Premier of Ontario from 1867 to 1871.

1870 – The first regatta is held in Muskoka among area settlers.

1870 – Rosseau House opens at the north end of Lake Rosseau. It is Muskoka's first grand wilderness hotel.

1871 – Locks are installed in Port Carling, linking Lakes Muskoka and Rosseau.

1872 – The Madill church is completed near Huntsville. Today, it is one of the few remaining log churches in Ontario.

1875 – The railway arrives in Gravenhurst.

1875 – Bracebridge is incorporated as a village.

1875 – Torrance is named after its first settler, William Torrance.

1878 – Gravenhurst has a population of 1,200.

1882 – Prospect House opens at Port Sandfield.

1883 – Beaumaris Hotel opens.

1883 – Rosseau House Hotel burns down.

1886 – Huntsville is named after Captain George Hunt, an English army officer who settled here in 1868.

1886 – The railway arrives in Huntsville.

1887 – Frank Micklethwaite arrives in Muskoka. This photographer documented the life and times of Muskoka for twenty years.

1890 – Dr. Norman Bethune is born in Gravenhurst.

1892 – The 68-foot *Naiad*, a private steam yacht, is brought to Muskoka for owner Senator William Sanford.

1894 – The Muskoka Lakes Association is founded. Today, it is the oldest cottagers' association in Canada.

1894 – Bracebridge becomes the first Ontario municipality to own its own power plant.

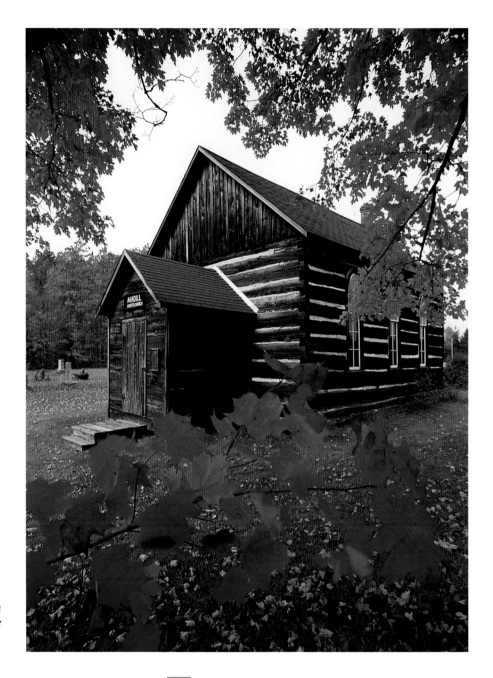

Madill Church
near Huntsville

1896 – The Deerhurst Inn opens as a wilderness retreat. Its founder, Charles Waterhouse, named it after an estate in England.

1901 – The MLA regatta is held at the newly opened Royal Muskoka Hotel, with 4,000 people in attendance.

1903 – The first automobile is seen in Bracebridge.

1905 – A.P. Cockburn, the father of Muskoka, dies. At the time of his death his navigation company is largest in the country.

1912 – The MLA begins annual motorboat races. (The last race is held in 1939.)

1913 – Woodrow Wilson, President of the United States, comes to Muskoka for the first time. He eventually buys an island here.

1913 – Canada's first brick summer resort, the Swastika Inn, opens in Bala. It is now the Cranberry Inn.

1914 – Sir Robert Borden, Prime Minister of Canada, and his wife are at the Royal Muskoka resort on Lake Rosseau when war is declared.

1914 – The disappearing–propeller boat is invented in Port Carling.

1915 – There are 329 gasoline–powered motorboats on the Muskoka lakes.

1920 – Bigwin Inn opens on Lake of Bays.

1924 – The founding of Duke Boats in Port Carling – today, the longest surviving boatbuilder in Muskoka.

1929 – Gerry Dunn opens a dance hall in Bala.

1934 – The steamship *Waome* capsizes and sinks on Lake Muskoka.

1940 – Chief Bigwin dies at age 101. Bigwin Island and Bigwin Inn were named after him.

1942 – C.O. Shaw, owner of Bigwin Inn, dies in Huntsville.

1952 – The steamer *Algonquin* is put out of service in Huntsville.

1955 – Santa's Village opens in Bracebridge. Long–distance swimmer Marilyn Bell swims from the Bracebridge town dock to mark the occasion.

1959 – Queen Elizabeth II visits Gravenhurst and attends the first peformance of music on the barge in Gull Lake Park.

1958 – The *Segwun* is retired.

1961 – The *Sagamo* is retired.

1962 – Gerry Dunn closes his dance hall in Bala.

1967 – The Port Carling Museum opens to celebrate Canada's 100th birthday.

1971 – The first Antique Boat Show is held at the Muskoka Lakes Golf and Country Club.

1981 – The RMS *Segwun* is relaunched.

1994 – The Muskoka Lakes Association celebrates its 100th anniversary.

Cottage calling cards

Muskoka chairs

John de Visser is one of Canada's premier freelance photographers. His photographs have appeared in such magazines as *Maclean's, Time, Life, Newsweek, Esquire, Sports Illustrated, National Geographic, Canadian Geographic, Der Stern* and *Paris Match*, and have been collected in more than forty books, including *This Rock Within the Sea*, with Farley Mowat; *Rivers of Canada*, with Hugh McLennan; *Winter*, with Morley Callaghan; and *Canada: A Celebration* and *City Light: A Portrait of Toronto*, with Robert Fulford. His awards include the National Film Board Medal for Still Photography, and Art Director's Club Awards of Merit from Toronto, Montreal and New York. In 1994 he was awarded a Lifetime Achievement Award by the Canadian Association of Photographers

and Illustrators in Communication. He is a member of the Royal Academy of Arts.

His outstanding collections for the Boston Mills Press include *Grand River Reflections, Muskoka, 1000 Islands, Credit River Valley, Summer Cottages, Georgian Bay, At the Water's Edge: Muskoka's Boathouses, Rideau* and *Storytelling Gardens*.

Judy Ross is a widely published freelance writer whose articles have appeared in numerous magazines, such as *House & Home, Cottage Life, Canadian Gardening, Leisureways, Town & Country* and *Travel & Leisure*. She travels extensively, filing her destination articles in various publications, including Canada's national newspaper *The Globe & Mail*. She is the author of a series of children's books about animals and of *Down to Earth: Canadian Potters at Work*. She previously collaborated with John de Visser on the Cottage Country bestsellers *Muskoka, Summer Cottages, Georgian Bay* and *At the Water's Edge: Muskoka's Boathouses*. When not travelling she divides her time between her home in Toronto and a boathouse in Muskoka.